a diner at 2 a.m.

a pretzel cart

the finish line of the New York City Marathon

sailing toy sailboats in Central Park

a bodyguard

a day at the races

a Coast Guard boat

a bill from the Four Seasons

a big tip

5Pointz

an angry barista

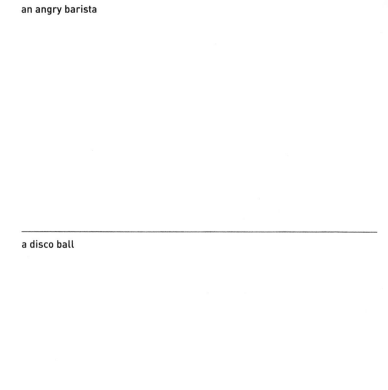

a disco ball

a billionaire | a $10,000 diamond-studded martini

a cougar	a Babe Ruth–autographed baseball
a black-and-white cookie	a Yankees pint glass

a bar during Fleet Week

a cargo bike

a boho store window display in Park Slope

walking across the Brooklyn Bridge

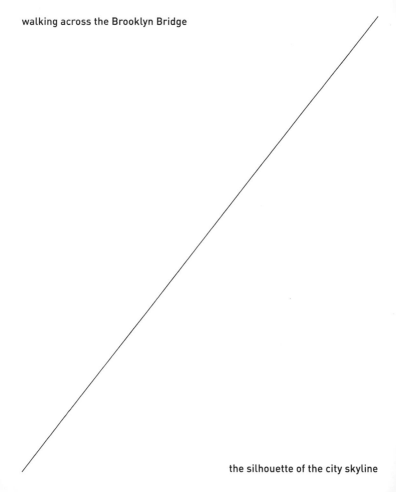

the silhouette of the city skyline

opening movie credits featuring a bird's-eye view of Manhattan

———

sushi from Nobu

a DJ | a book editor

a Brooklyn brownstone

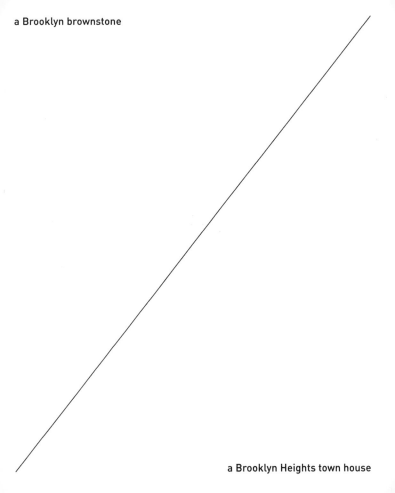

a Brooklyn Heights town house

wildlife at Jamaica Bay

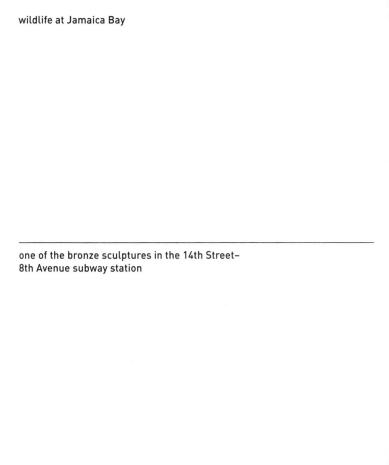

one of the bronze sculptures in the 14th Street–
8th Avenue subway station

a bouncer

a Giants fan

a street performer

a captain of industry

a skateboarder

a Brooklyn chicken coop

a Christie's auction item

Park Avenue in the snow

the *Village Voice*

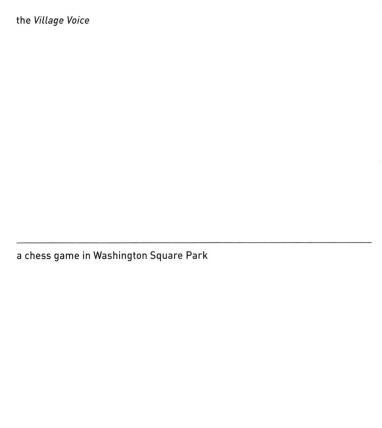

a chess game in Washington Square Park

an Empire State Building commemorative spoon

playing Frisbee in Prospect Park

a construction zone

down and out

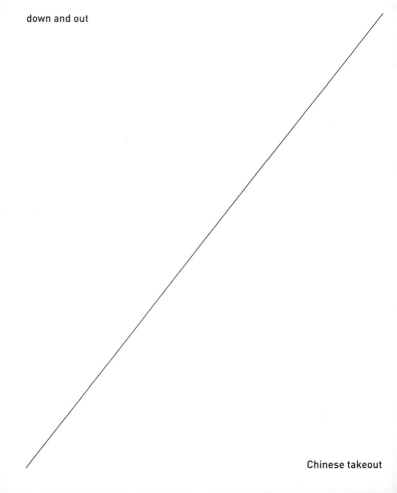

Chinese takeout

sunbathers at Rockaway Beach

a celeb sighting

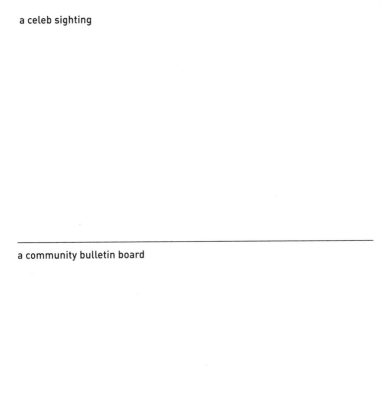

a community bulletin board

elevator buttons	a bedbug
a Manhattan	a dimly lit corner table

the American Museum of Natural History's blue whale

4 a.m.

Stuyvesant Town

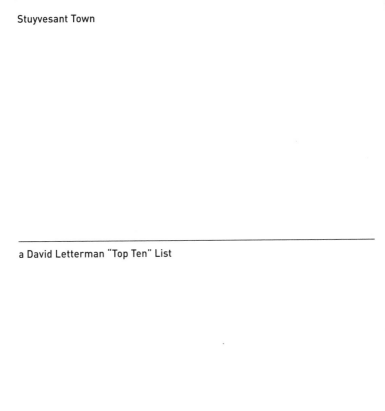

a David Letterman "Top Ten" List

a spectacular chandelier

a crane

a deserted alley

breakfast at Tiffany's

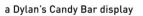
a Dylan's Candy Bar display

a Polish grandmother in Greenpoint

a Columbia University student during finals

looking out over the rooftops

the *Triumph of Civic Virtue* sculpture

a vintage bike

a double-decker bus

a Statue of Liberty crown hat

a poser | a cosmopolitan

a Park Avenue mom | a dirty martini

Dr. Brown's Cream Soda | a fashion blogger

a curated lifestyle boutique in Nolita

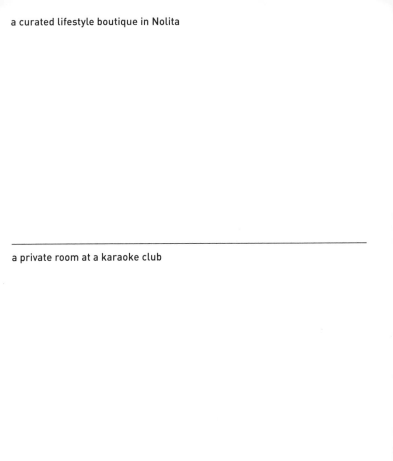

a private room at a karaoke club

a dollar cart outside the Strand

a three-Michelin-star restaurant

a display case at C.O. Bigelow Chemists

a Yankees foam finger

a gem-encrusted handbag

a fashion show finale

a pizza delivery guy	a double stroller in Park Slope
a squirrel	a fifth-floor walk-up

a dive bar

a style uniform

a bookstore cat

a tourist with a fanny pack

using a selfie stick

a display of jewels in the Diamond District

a savvy real estate broker

making a statement

a slave to fashion

a favorite bookstore

a graphic designer huddled over a MacBook

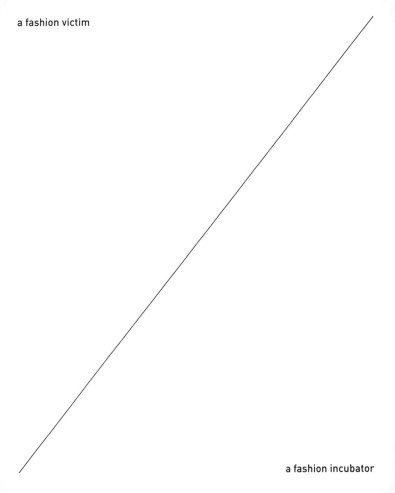

a fashion victim

a fashion incubator

a 5th Avenue mansion

a gallery opening

a doorman | a gangster

Fire Island

a Harlem gospel choir

a Brighton Beach babushka | a gyro in Queens

kale and beet juice | a runway model

a food co-op

a hip-hop star

a horse-drawn carriage ride

a freelancer working in a café

a Jewbano sandwich

a Fashion Institute of Technology student

a Greek deli

a hot dog–eating contest contestant

a Krispy Kreme doughnut

the ladies who lunch

a "One Way" sign

a fashionista in Nolita	a hedge fund manager
a Knicks jersey	a MetroCard

a Greenwich Village café

a Magnolia Bakery cupcake

a Midtown street at lunch hour

a gossip columnist

a secret supper club

Life magazine

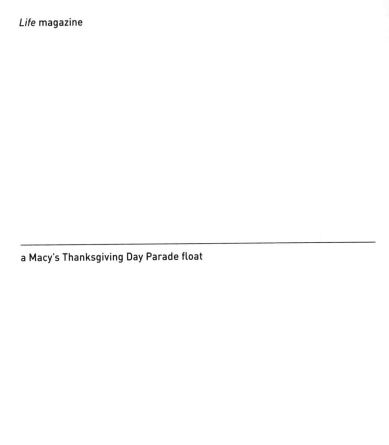

a Macy's Thanksgiving Day Parade float

a gorgeous bartender

a literary salon

a hot dog vendor

a native New Yorker

a MoMA gift shop souvenir

a Piet Mondrian painting

a mural in Williamsburg

a plate of cannoli

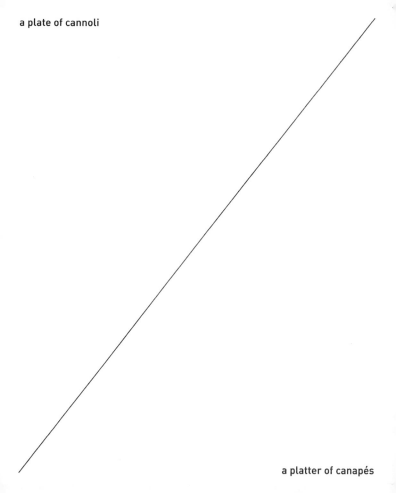

a platter of canapés

a monogrammed canvas tote for the Hamptons	a juggler
a man in black tie	a Cronut

a meatball sandwich

a pair of Broadway tickets

dinner for two at the River Café

a pair of Manolos

a pampered pet

a mustard sommelier

a Mets T-shirt | commuting on an electric unicycle

a luxury condo tower | a jogger

a map of Central Park

Stone Street at happy hour

a fire escape | a mafioso

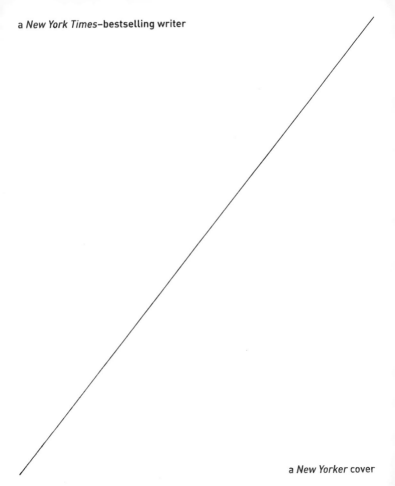

a *New York Times*–bestselling writer

a *New Yorker* cover

a local designer	a high-profile lawyer
a street preacher	a movie producer

a New York–themed tattoo

a pedicab

a Riverside Park
bench at dawn

a peekaboo view of the
Brooklyn Bridge

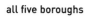
all five boroughs

a meat market

a packed Circle Line cruise

a newsstand

St. Paul's Chapel

a porterhouse steak at Peter Luger Steak House

a debutante | a power suit

an "NYC monuments" snow globe

"Start spreading the news . . ."

a pub crawl

a restaurant aquarium

a quaint street in the West Village

a dog walker

a sea of cabs

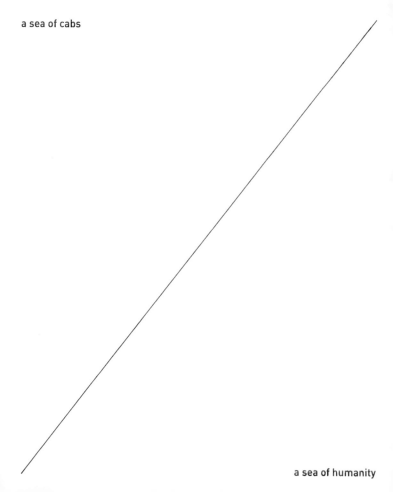

a sea of humanity

a mixologist

Carnegie Hall

a singles' scene

a random act of kindness

a bike commuter on the Brooklyn Bridge

a dapper Upper East Side gentleman

a purse snatcher

a cashmere hoodie and sweatpants

a preppy

a celebrity chef | a Pratt design student

an aspiring rapper | a professor

a souvenir belly-button ring

a personal trainer

a rare orchid shop

the Rockettes

a one-percenter

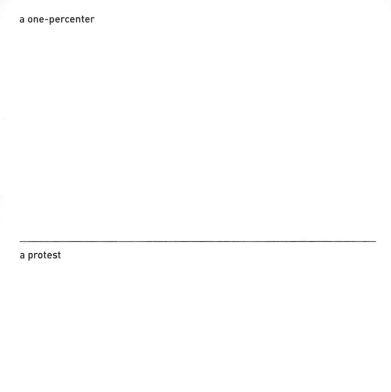

a protest

a gala

row boating on the Lake

a real Rolex

a regular at Sunny's Bar

a bodega

a peregrine falcon

a Hasidic rabbi

an alligator that lives in the sewer

a millionaire | a rooftop beekeeper

a saxophone player | a sculpture on the Met's roof garden

a Red Hook warehouse-turned-art gallery

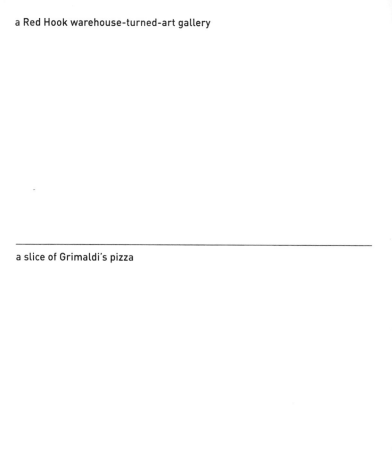

a slice of Grimaldi's pizza

the description of a ridiculously priced apartment for rent

a bike messenger

a Saks Fifth Avenue window display

a sari shop

a sidewalk café table

a Duane Reade

a room with a view of a brick wall

a shady character

a motorcycle jacket

a snowman in Central Park

a restaurant critic
in disguise

a water tower

the trading floor of the New York Stock Exchange

the Harlem Globetrotters

a stickball game

a Staten Island mansion

a Bloody Mary brunch

Amateur Night at the Apollo

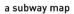
a subway map

a boom box

a super-stretch limo

a chauffeur

a temporary art installation

a window display of bagels and bialys

a subway car at rush hour

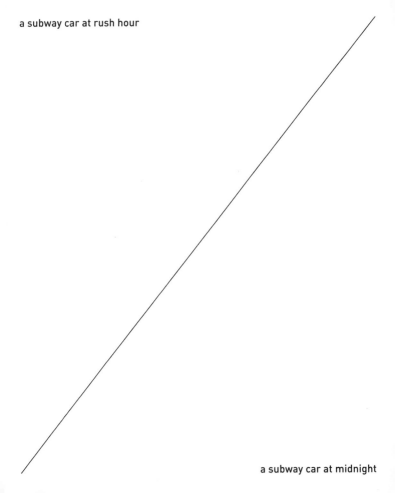

a subway car at midnight

a security guard

a Silicon Alley–startup
founder

the Queensboro Bridge

a trendy noodle bar menu

a SoulCycle "Front Row" T-shirt

cherry trees in bloom at the Brooklyn Botanic Garden

a WASP

a traffic jam

a synagogue

a too-tiny apartment

a person in the St. Patrick's Day Parade

a singing waiter

the Mudtruck

a three-martini lunch

a Tribeca loft

a theater production in an abandoned warehouse

a sketch artist

a burlesque performer

a stand-up comedian | dude with a mohawk

a vintage garment from the Brooklyn Flea

a tattoo parlor

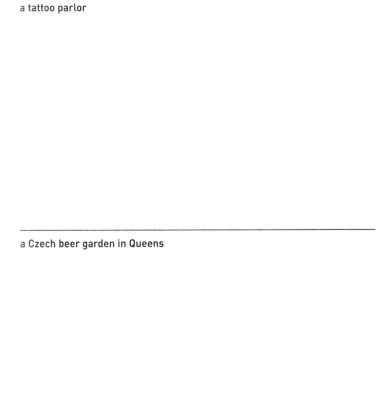

a Czech beer garden in Queens

a struggling actor | a takeout menu

a trendy mixologist | a Wall Street tycoon

a bagel with lox

a vinyl shop

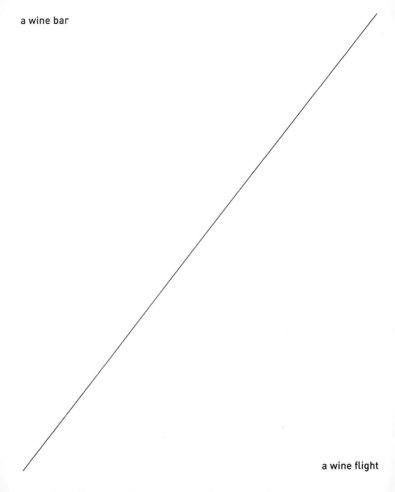

a wine bar

a wine flight

an artisanal picnic in Prospect Park

an abstract public sculpture

incognito baseball cap and sunglasses

adoring fans at a movie premiere

a broken-in pair of Doc Martens

a window table at the Rainbow Room

a Wall Street bar at happy hour

a tweedy man with a pocket watch	a taste maker

a wannabe beatnik

a wide-eyed innocent
on his first day in town

bright lights, big city

an NYPD badge	an egg cream
a bottomless cup of coffee	a water taxi

a weekend soccer game in Chinatown

an alligator-skin iPhone case

Instagramming your artful cappuccino

Allen Ginsberg

a Williamsburg hipster

the statue of Lenin

an East Village punk

a Zabar's coffee mug

Alexander Calder's *Saurien*

a speakeasy

an artfully presented seafood dish at Le Bernardin

an avant-garde dessert

a swank cocktail lounge

a poetry reading

a vaudeville act

a vegan cleanse delivery menu

break dancing

bling

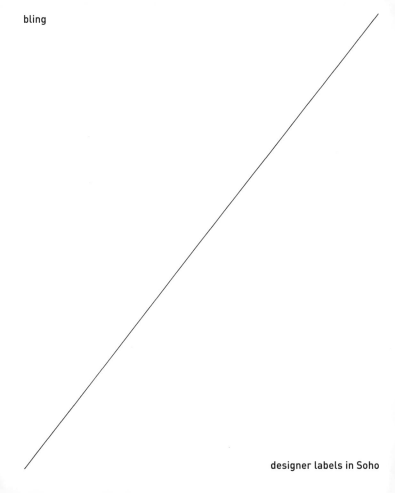

designer labels in Soho

an off-duty model	a cabbie

an East Village vintage shop

an artists' colony

an Arthur Avenue
Market vendor

an East Village vegan

an indie bookstore owner

an A-lister

an escalator

an umbrella vendor on a rainy day

an outdoor concert in Central Park

a Lower East Side indie designer boutique

arm candy

an Irish pub

Carrie Bradshaw

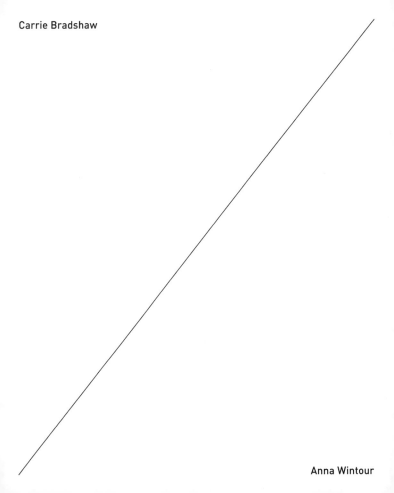

Anna Wintour

an expense-account dinner

an "I [heart] NY" T-shirt

an edible chocolate teacup	an intellectual
an overworked first-year investment banking analyst	an unmarked bar

the Duke Ellington Memorial

Bogie's Corner at the 21 Club

one of Arrechea's *No Limits* sculptures

the Gay Pride Parade

Bethesda Fountain

an old-school watering hole

barefoot in the park

Batman

fashion sneakers

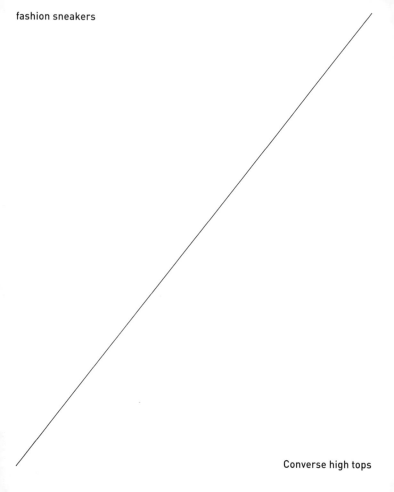

Converse high tops

summer in the city

the Chinese New Year Parade

a swish rooftop bar

Bryant Park at lunchtime

DUMBO's Waterfront Park

| an NYU student | an outrageous Halloween costume |

| an über-perky fashion publicist | Billie Holiday |

a high-ceilinged East Village co-op

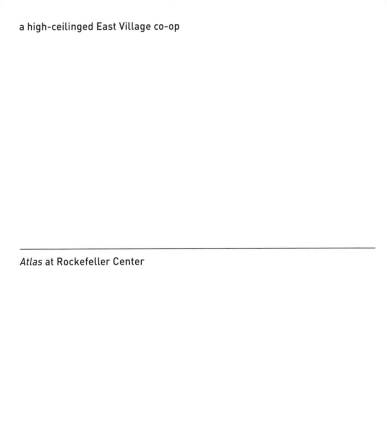

Atlas at Rockefeller Center

Belvedere Castle

pastrami on rye

Christmas window displays

an aspiring novelist

an avant-garde art gallery

dirt

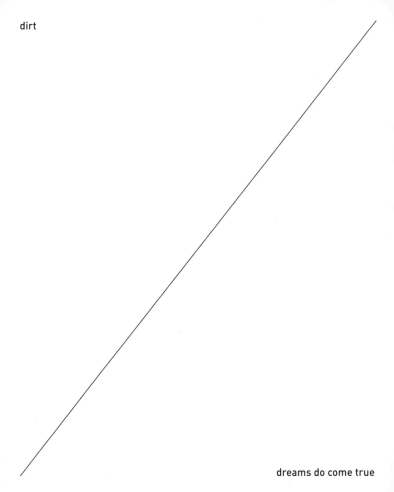

dreams do come true

Keith Haring's *Crack Is Wack* mural

Boss Tweed

Canal Street crowds

the Grand Army Plaza arch

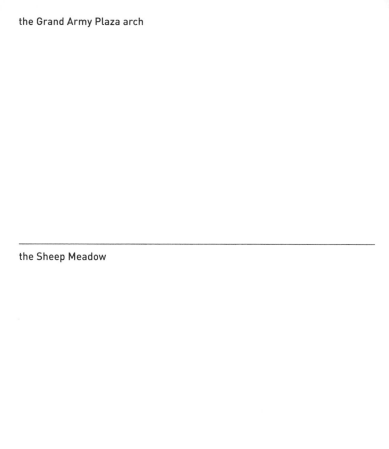

the Sheep Meadow

a manhole cover

construction workers lunching atop a half-built skyscraper

enjoying an ice cream cone at Fulton Ferry Landing

contrasts

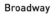

Broadway

busking in the subway

dog owners at Tompkins Square Park

Bloomingdale's

Mondrian's *Broadway Boogie Woogie*

boogie down

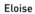
Eloise

getting past the velvet rope

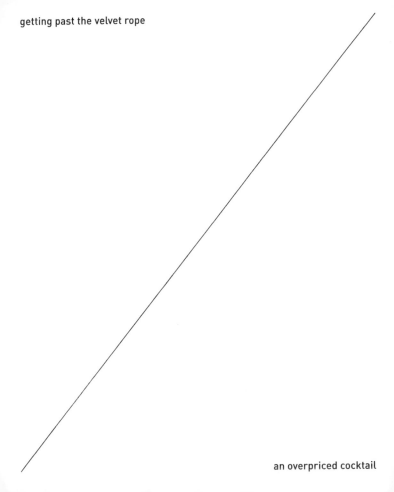

an overpriced cocktail

Fourth of July fireworks

dancing the night away

George Washington's inauguration on Wall Street

front row at Fashion Week

cocktail hour at the Plaza's Oak Bar

Cats

a snowy day

feasting in Koreatown

| Clark Kent | Superman |

fortune cookies

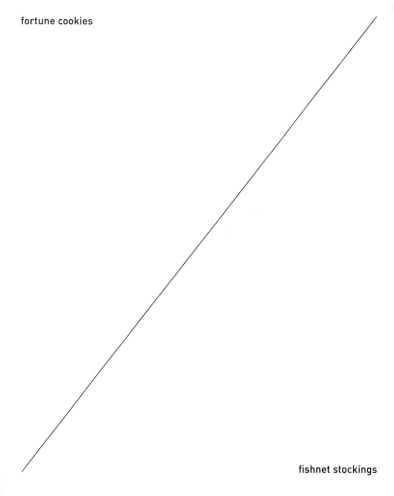

fishnet stockings

Columbus Circle at rush hour

a movie set

gentrification

Customs at JFK

first sighting of the City as seen from the airport shuttle

Don Draper

Ella Fitzgerald

Gracie Mansion

Holly Golightly

New Year's Eve in Times Square

crowds thronging a sample sale

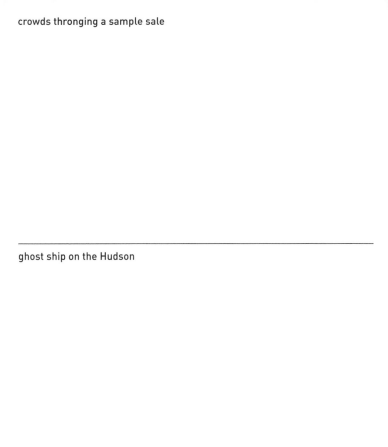

ghost ship on the Hudson

catfish and collard greens in Bed-Stuy

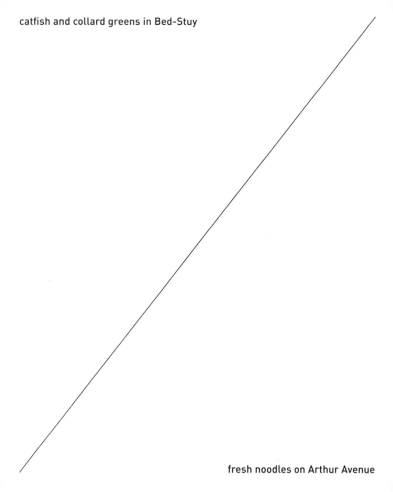

fresh noodles on Arthur Avenue

graffiti

getting discovered

stoop sitting

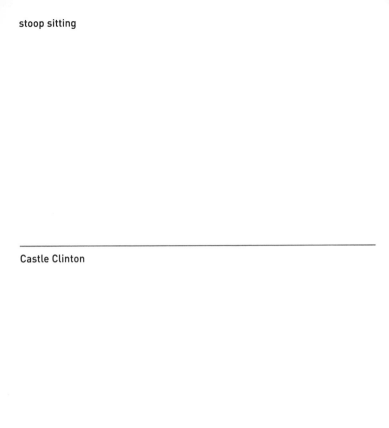

Castle Clinton

celeb spotting at
the Waverly Inn

a snarky blogger

Edith Wharton

Grant's Tomb

Gotham

Green-Wood Cemetery in autumn

Ellis Island

Fraunces Tavern

hungover

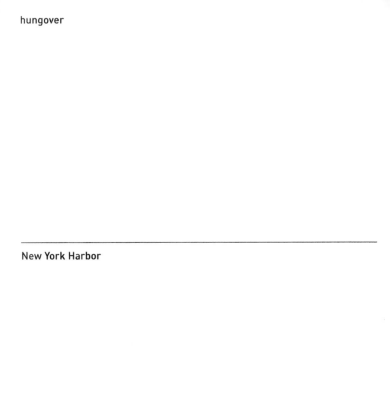

New York Harbor

strappy sandals in the grass

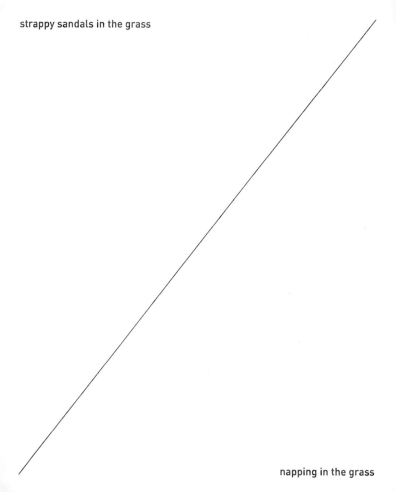

napping in the grass

impossible-to-get theater tickets

not a free cab in sight

latkes

Grand Central Terminal at rush hour

only in New York

living the dream

Grand Central Terminal's four-sided clock

Hamptons fashion

King Kong

JFK on the Wednesday before Thanksgiving

lines snaking outside Shake Shack

manhole cover cuff links

Isamu Noguchi's *Red Cube*

Imagine mosaic

label conscious

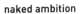

naked ambition

Murray's cheese counter

in costume on the subway on a day other than Halloween

Jackie O.

Martin Scorsese
at work

the Olsen twins

late-night borscht at Veselka

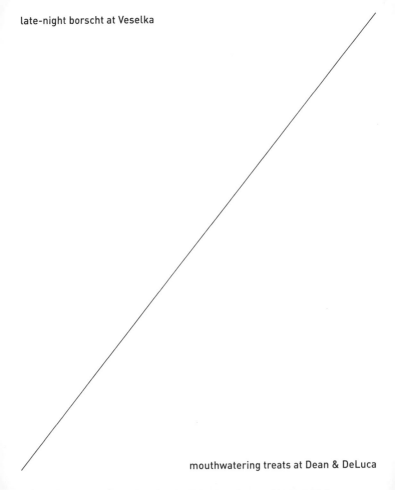

mouthwatering treats at Dean & DeLuca

pigeons

overflowing trash

multiple piercings

opening day at Yankee Stadium

opening night at Lincoln Center

Katz's Delicatessen

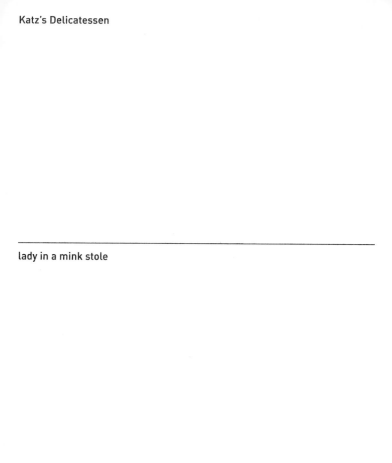

lady in a mink stole

lunch al fresco at Tavern on the Green

a pug with a rhinestone collar

Gatsby and Daisy | Lucky Luciano

Brooklyn street art

movie night in Bryant Park

Moonstruck

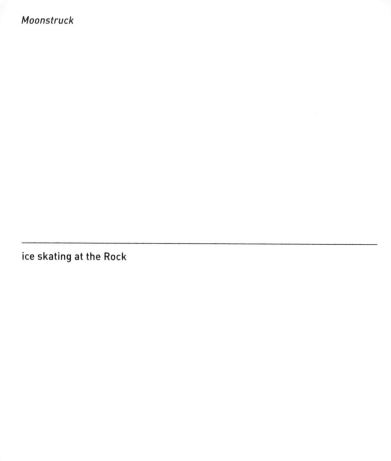

ice skating at the Rock

newlyweds outside the city clerk's office	cheesecake
Peking duck hanging in the window	a sailboat on the Hudson

post–soccer game beer with the adult team

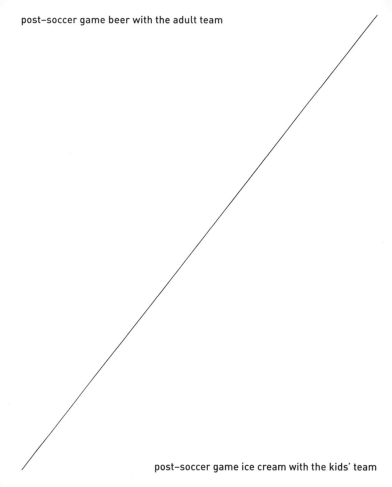

post–soccer game ice cream with the kids' team

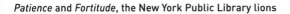
Patience and *Fortitude*, the New York Public Library lions

shelves of souvenirs

a mah-jongg game in the park

reading *Vanity Fair*

eating a sandwich on a bench

a bachelorette party in the Meatpacking District

overworked and underpaid

rats

Robert De Niro strolling
in Tribeca

a bride arriving at the
Waldorf Astoria

shoes hanging from
an electric wire

a barrel of pickles

an off-off Broadway show

roommates

people-watching on the High Line

something you never thought you'd see in public

opera in the park

kite flying

Occupy Wall Street

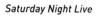
Saturday Night Live

rocking out with headphones

rocking the dance floor

running through the rain | shooting hoops

the Dragon Boat Festival

the New York Philharmonic

subway art

subway symbols

shopping bags

a titan of finance smoking a cigar

a matza bakery

swarming with tourists

the finish line at the Empire State Building Run-Up

Serendipity 3

the lobby of the Ace Hotel

spaghetti and meatballs in Little Italy

skinny woman in a puffy black parka

St. John the Divine

the Algonquin Round Table

a girl with long hair tucked inside her coat collar

the butterfly garden at the Bronx Zoo

the Unisphere

St. Patrick's Cathedral

students on the steps outside Columbia's Low Library

the Battery Park Esplanade on a Sunday morning

a concert at Madison Square Garden

Manhattanhenge

South Street Seaport Museum's *Wavertree* ship

the Bronx's Grand Concourse

the Central Park Dairy

on the steps of the
Met Museum

the apartment windows
across the street

stiletto heels

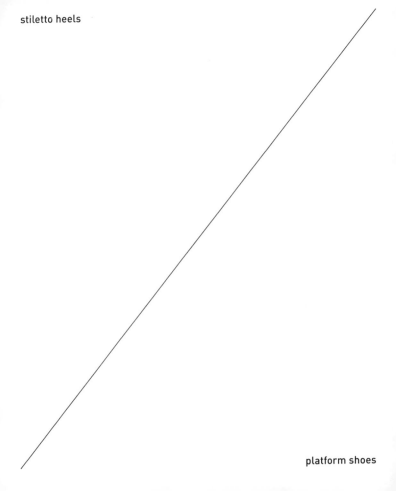

platform shoes

a bowl of ramen | a skim latte

city hall | the *LOVE* sculpture

Studio 54 at 4 a.m.

the Roosevelt Island Tramway

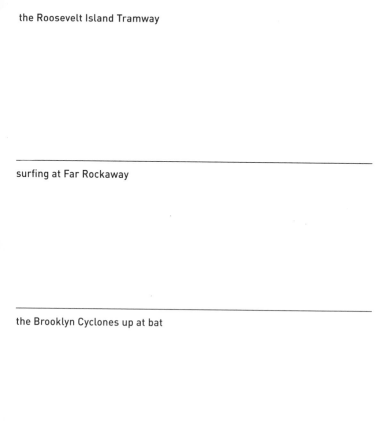

surfing at Far Rockaway

the Brooklyn Cyclones up at bat

a dim sum cart

the buried treasure on Liberty Island

suddenly bankrupt

Coleman Skatepark

the Cyclone at Coney Island

the Grand Central Terminal ceiling

a ticker-tape parade

the crowd at the NYC Vegetarian Food Festival

see and be seen

the New York Public Library's Reading Room

the *Alice in Wonderland* statue | the *Double Check* sculpture

the *Tribute in Light*

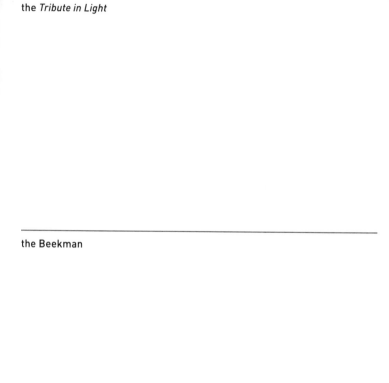

the Beekman

the Blue Note in its heyday

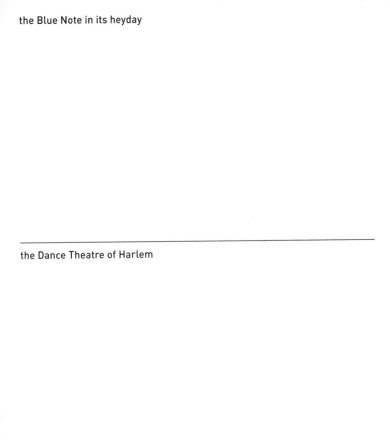

the Dance Theatre of Harlem

the epitome of style

the Bushwick Book Club | the Dakota

the Cotton Club | Port Authority

the bowler hat from
The Thomas Crown Affair

the *Gay Liberation* sculpture

Chelsea Piers

the Loeb Boathouse

the flags outside the United Nations Headquarters

sledding on Pilgrim Hill

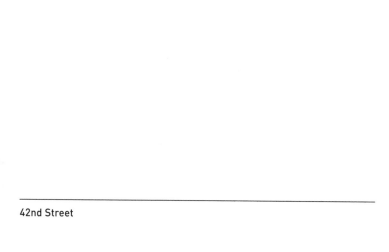

42nd Street

the elevated J train in Queens

the food vendors at the Red Hook Ball Fields

the Grand Central Oyster Bar

a street vendor	a Brooklyn Folk Festival performer
the Graffiti Hall of Fame	nail art

bargain hunting at Century 21

the contents of a Dylan's Candy Bar time capsule

the "bridge and tunnel crowd"

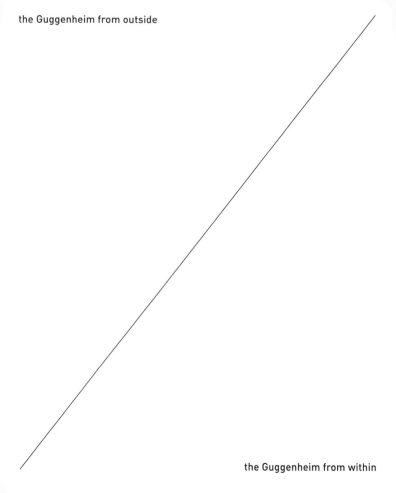

the Guggenheim from outside

the Guggenheim from within

the Lincoln Center Plaza
fountain

the Domino Sugar factory

the Gotham Girls Roller Derby

the delights of Smorgasburg

the first warm spring day

the Chrysler Building

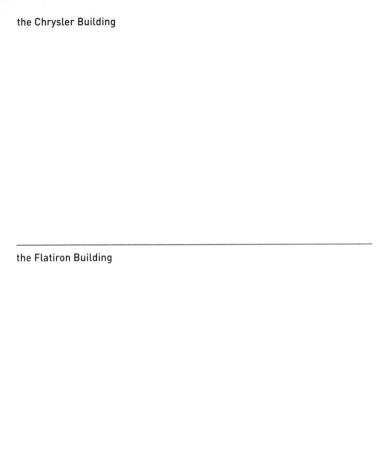

the Flatiron Building

the Harlem Renaissance

shaken, not stirred

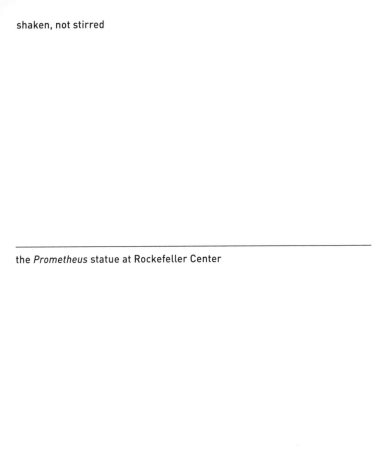

the *Prometheus* statue at Rockefeller Center

the Greenwich Village Halloween Parade

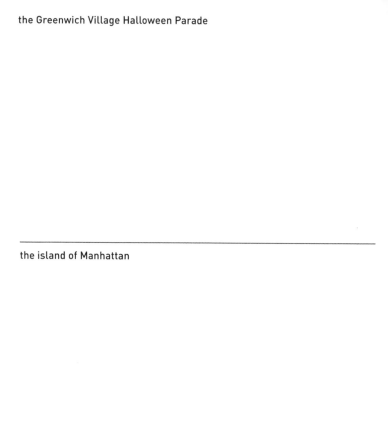

the island of Manhattan

the marquee of the Apollo

a dashing couple

the New Jersey skyline

the *Little Bo Peep* statue

a book of matches
from Delmonico's

smoked fish at
Russ & Daughters

the Soho House pool
on a hot day

the night sky as seen at Hayden Planetarium

the ball dropping on
New Year's Eve

the Empire State Building
lit for Valentine's Day

the Jazz Age

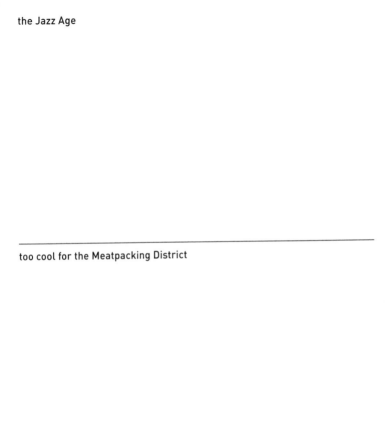

too cool for the Meatpacking District

the Mermaid Parade

the New York Road Runners Midnight Run

the salad bar at the Lower East Side Whole Foods

the New Museum of Contemporary Art	the outdoor library in Bryant Park
the penthouse suite	the space shuttle *Enterprise*

the view from the Brooklyn Heights Promenade

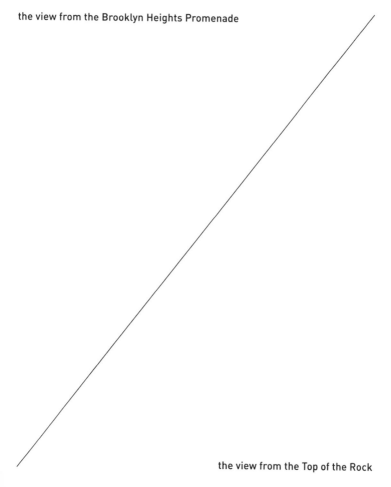

the view from the Top of the Rock

the Yankee Stadium scoreboard

the *Wall Street Journal* masthead

the Staten Island Ferry

Radio City Music Hall

the San Gennaro Festival in full swing

the light in autumn

the Styleliner mobile fashion truck

the tufted puffins at the Central Park Zoo

the view from Governors Island | Trump Tower

Stuart Little | Woody Allen

the Statue of Liberty | the Survivor Tree

the opening scene from *West Side Story*

the Wall Street bull

the grill at Dinosaur Bar-B-que

the *Seinfeld* diner

Holden Caulfield

serenity in the Cloisters' courtyard

the Wonder Wheel at Coney Island

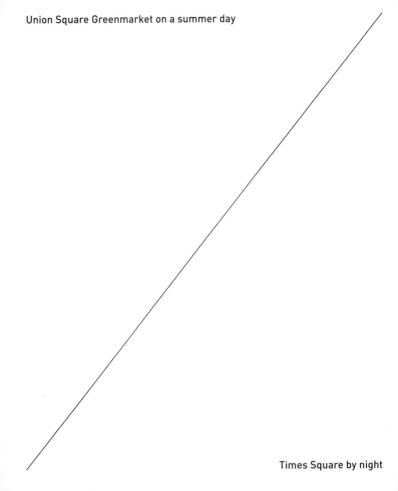

Union Square Greenmarket on a summer day

Times Square by night

the Sunday *New York Times*

the Stonewall Inn

the tree root sculpture
outside Trinity Church

the top shelf

waffles from a food truck

Freedom Tower

the Washington Square Arch

tightrope walking between skyscrapers

a counterfeit Rolex

walking home at dawn

Van Gogh's *The Starry Night*

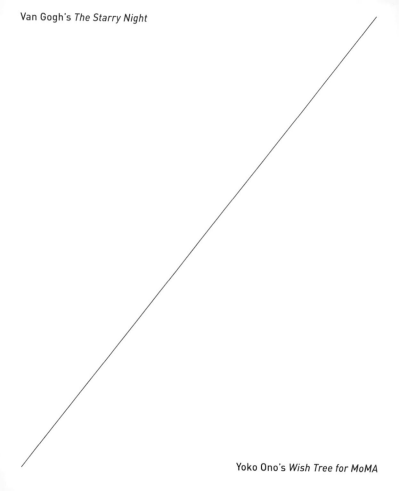

Yoko Ono's *Wish Tree for MoMA*

a box of Jacques Torres chocolate truffles

walking the red carpet at the Tribeca Film Festival

Vogue

The Unicorn Tapestries

Trinity Church

the Fringe Festival

a *New Yorker* cartoon

the life of the party